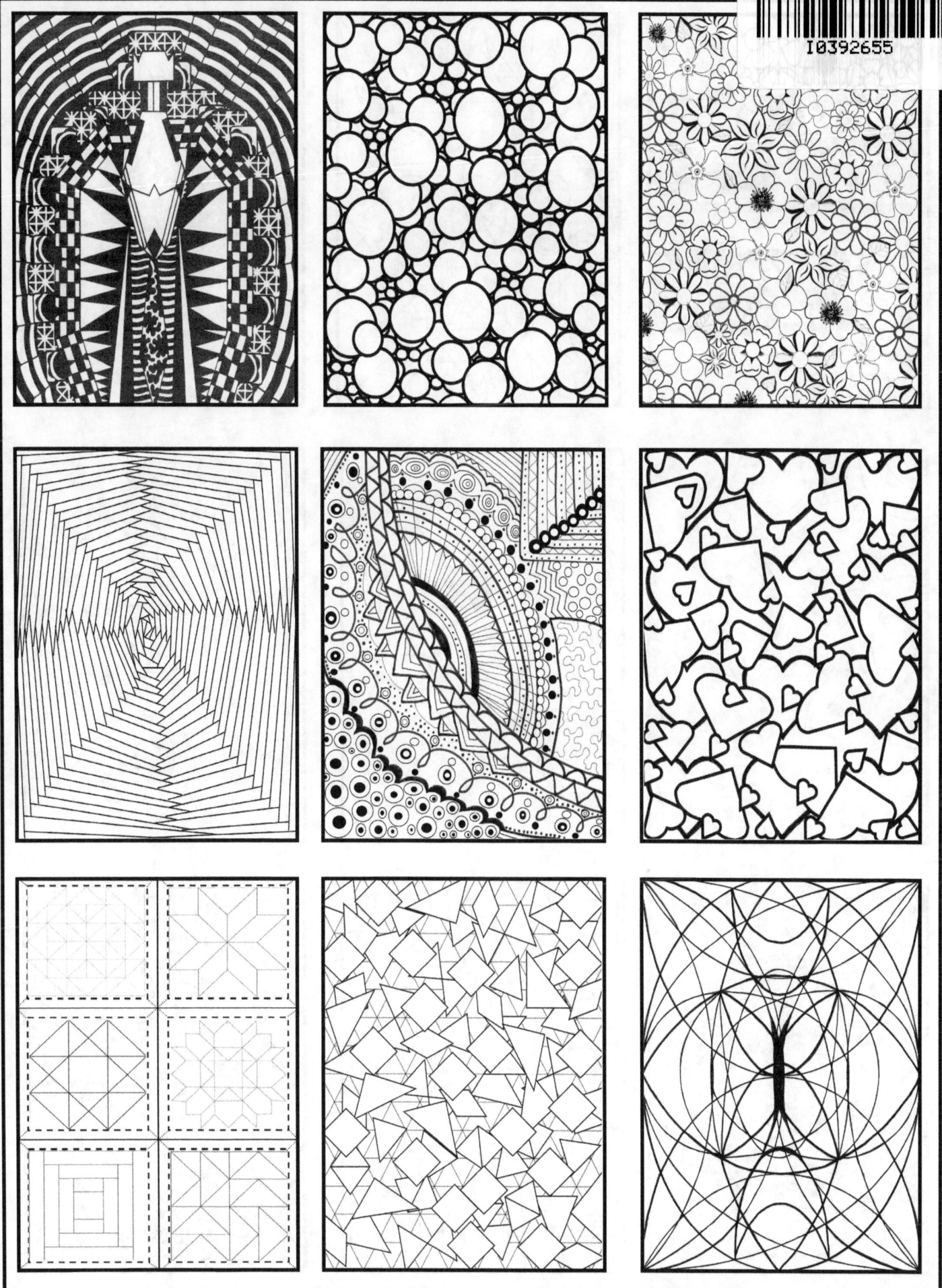

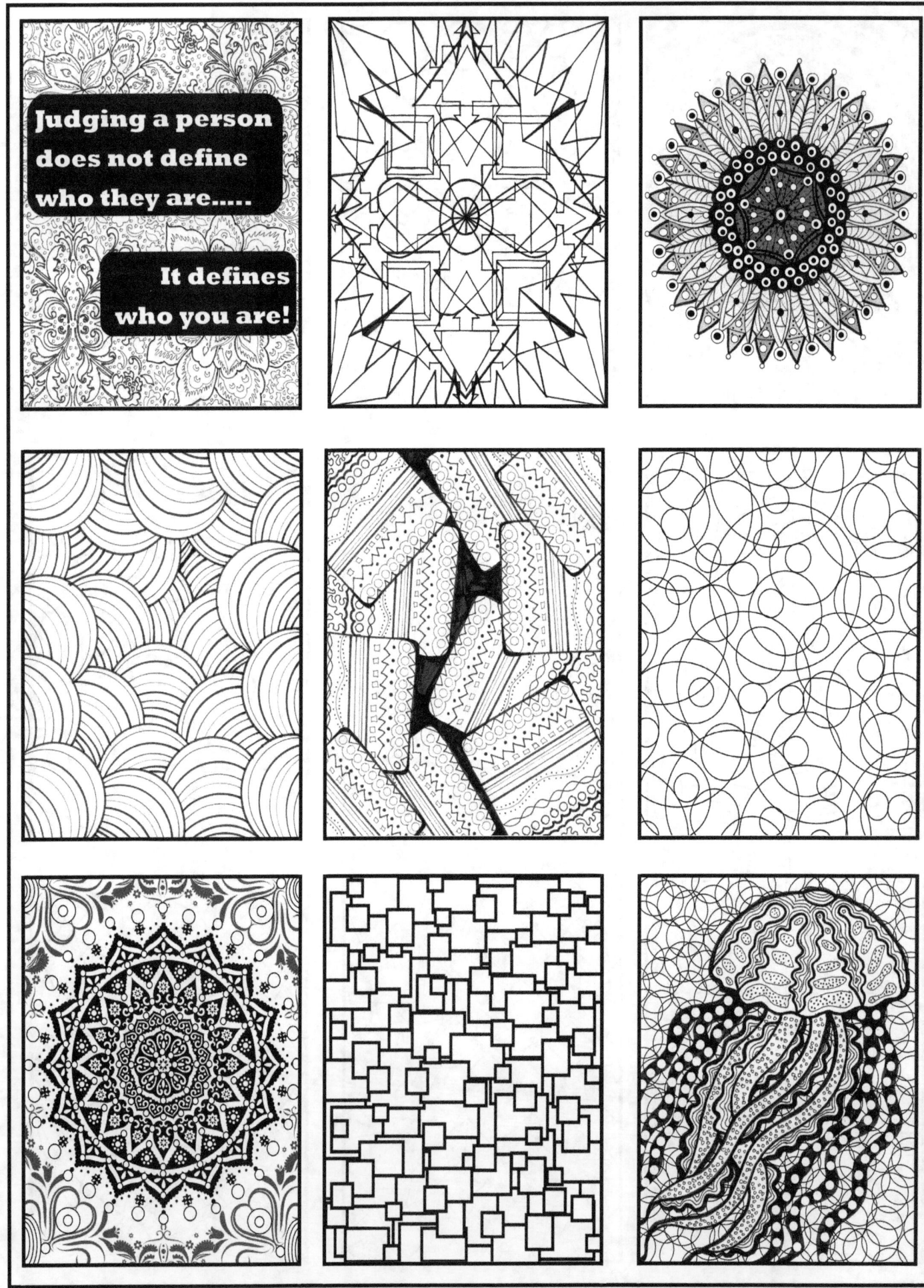

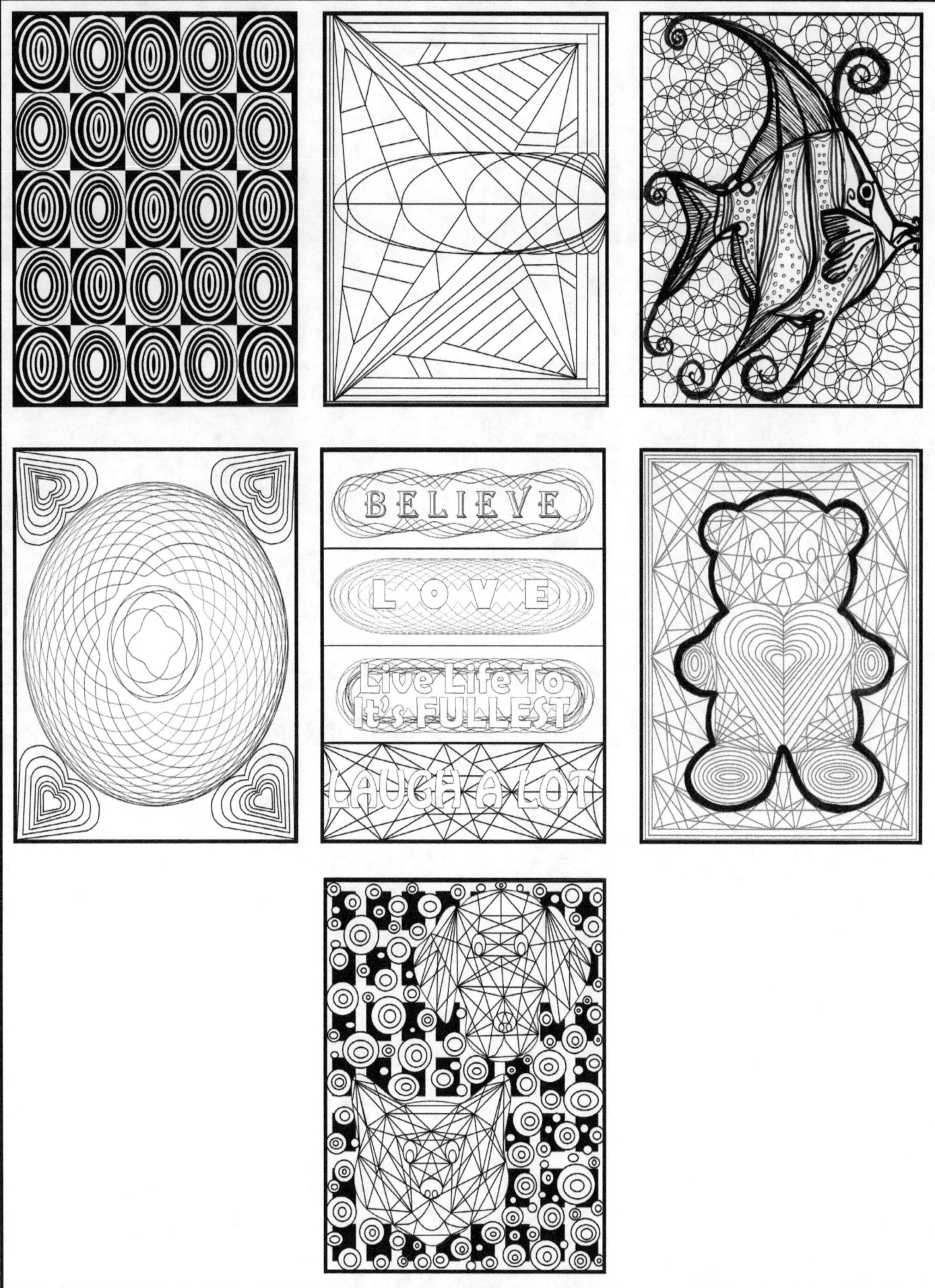

DIDDLE DADDLE DOODLES #1

ORIGINAL EDITION

Adult Coloring Book

Animals, Nouveau, Geometric, Garden, Flowers
Bookmarks, Sea Life, Mandalas and so much more!

Jeffrey S. Thomas

COPYRIGHT NOTICE
©Jeffrey Scott Thomas
Diddle Daddle Doodles #1
Original Edition
September 1, 2016

Copyright 2010
@ Jeffrey Scott Thomas
Little Devils Doodles
Original from:
September 2010

Dedicated to my wife who stood by my side to make me stronger!

Dedicated to my little girl Aurora who gives me reason to wake up and know life is great!

Dedicated to my Mom for the unconditional love she has always provided!

Dedicated to my sons for making me see a new world I never knew I did not know!

Dedicated to family and friends who have been there with me thought the thick and thin!

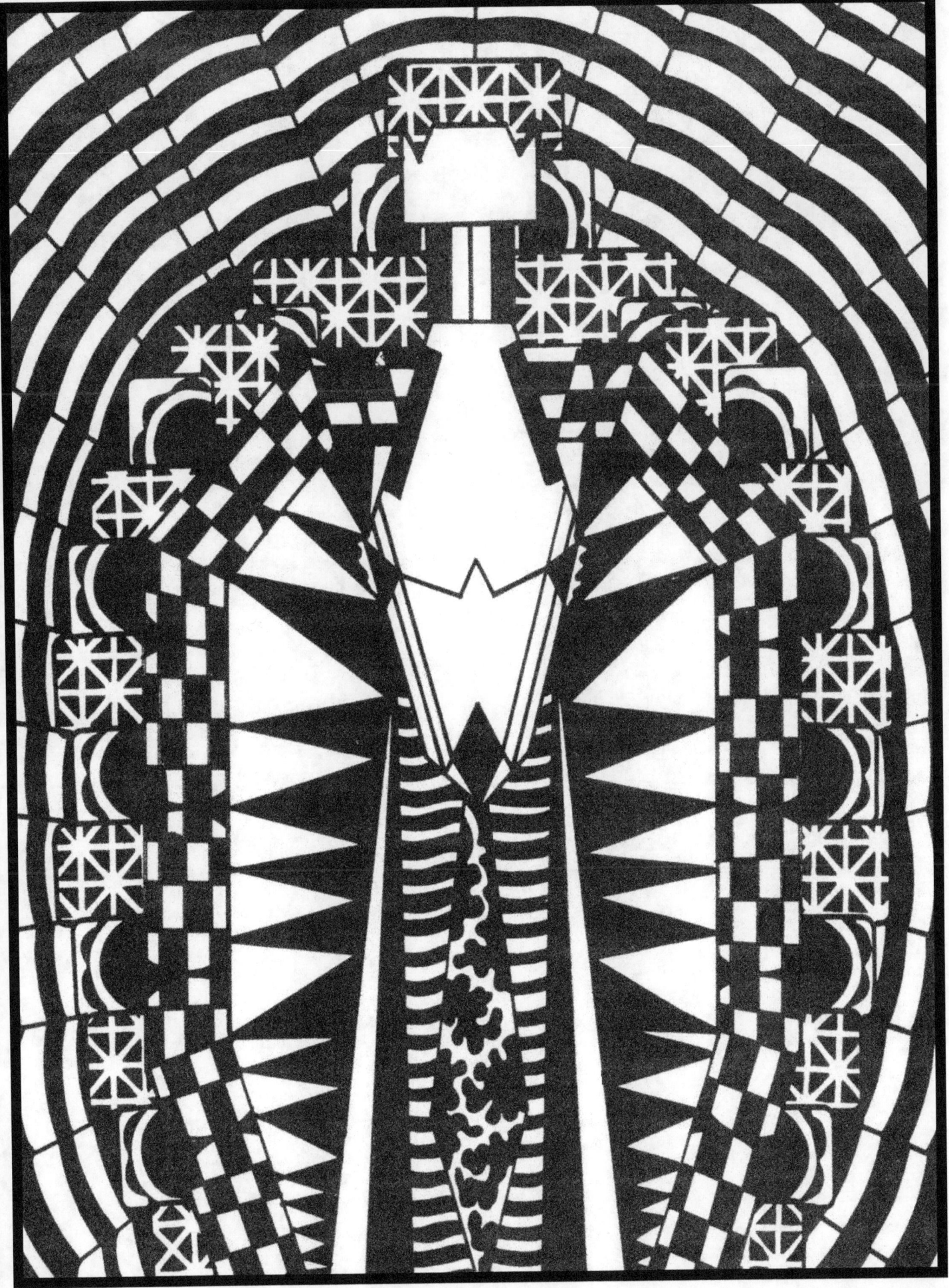

Diddle Daddle Doodles #1
Original Edition

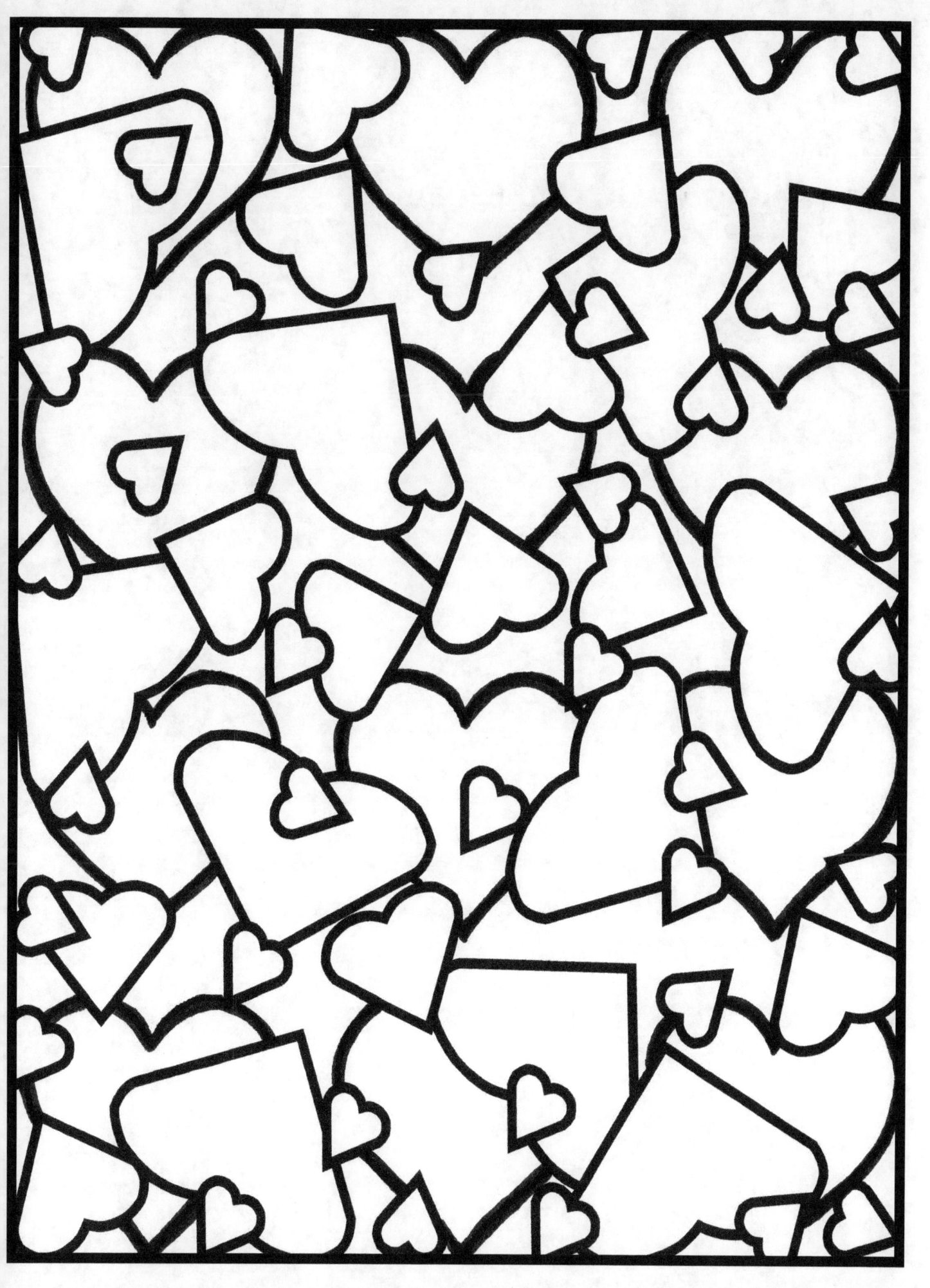

Diddle Daddle Doodles #1
Original Edition

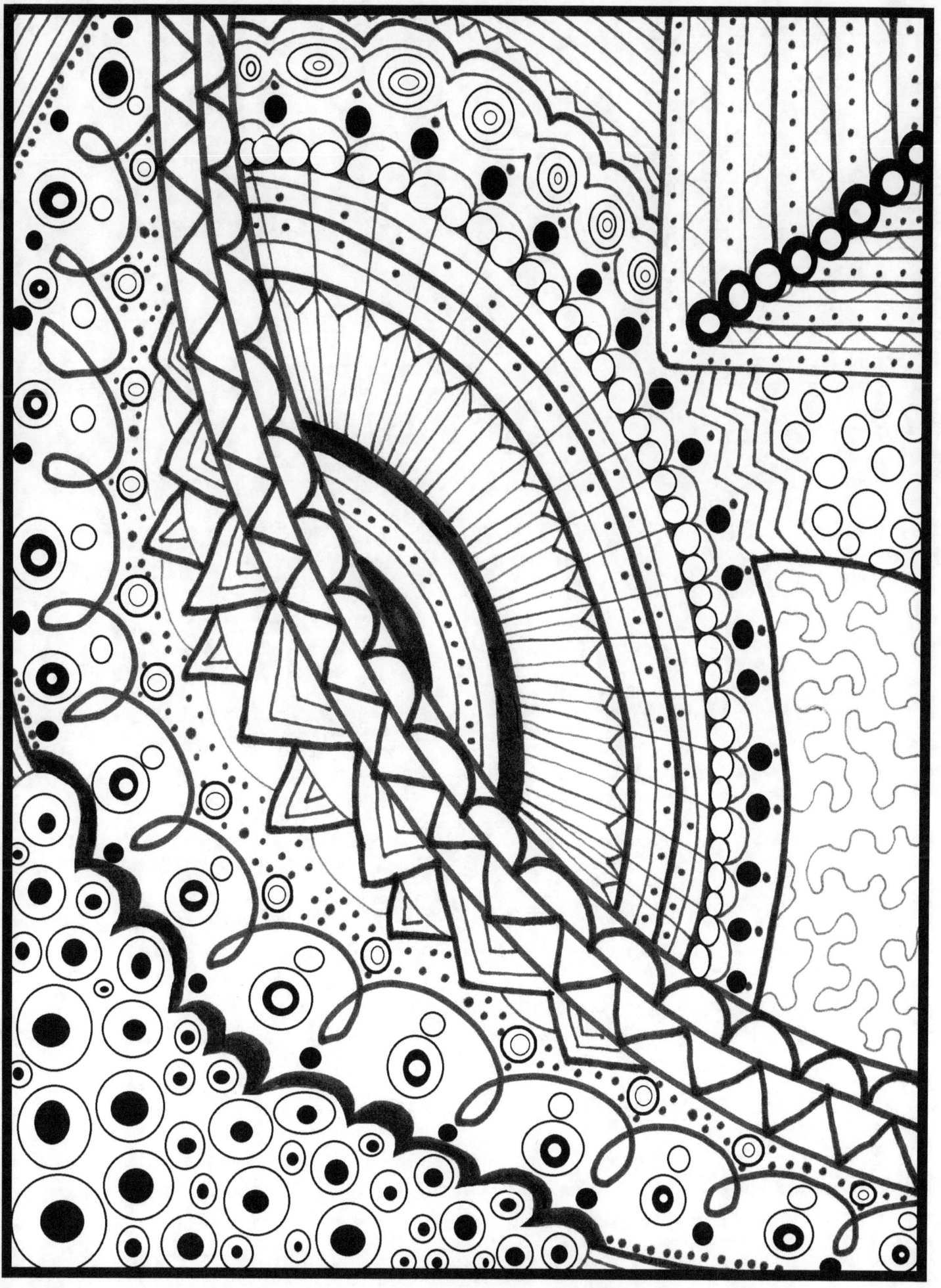

Diddle Daddle Doodles #1
Original Edition

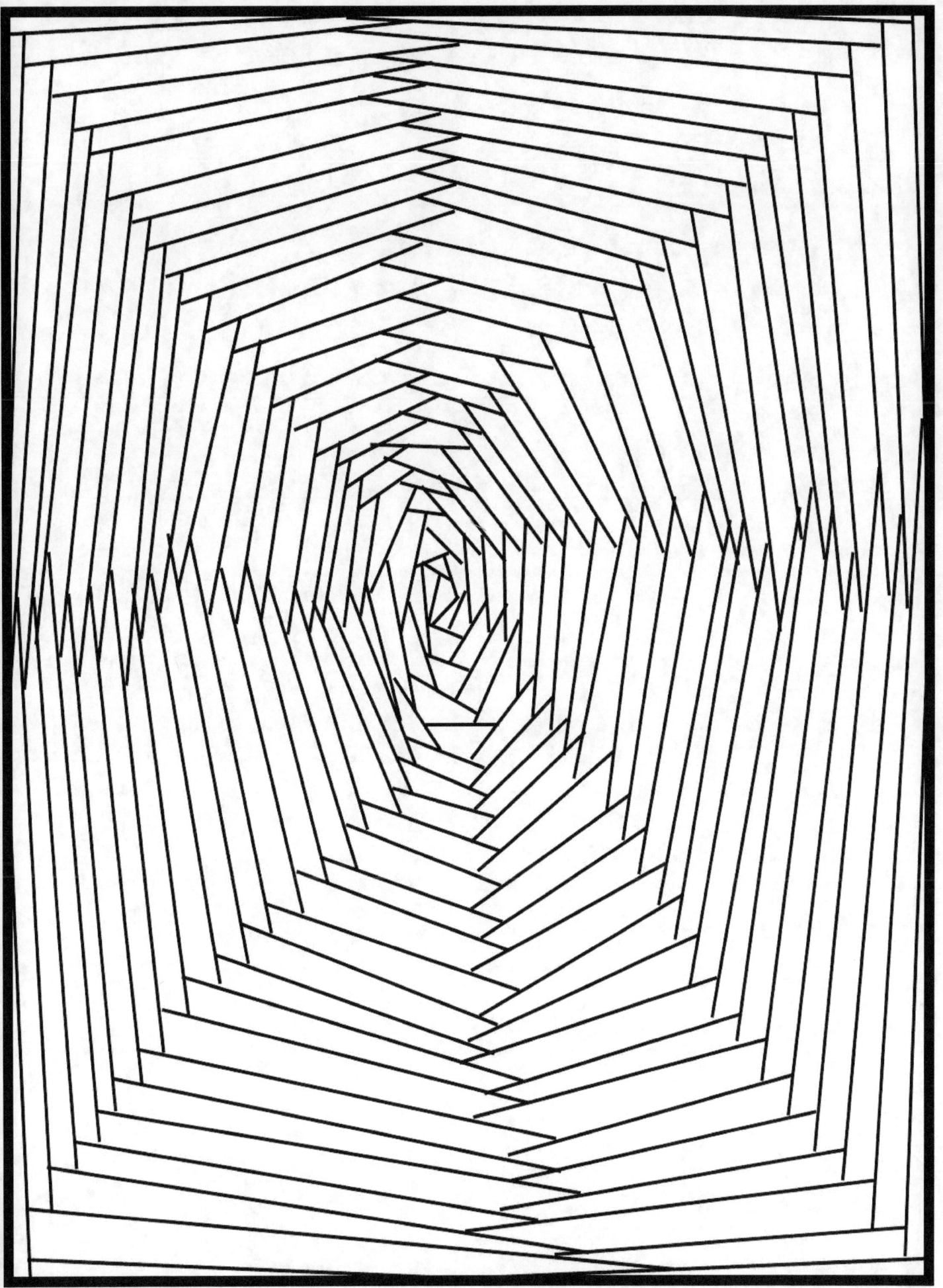

Diddle Daddle Doodles #1
Original Edition

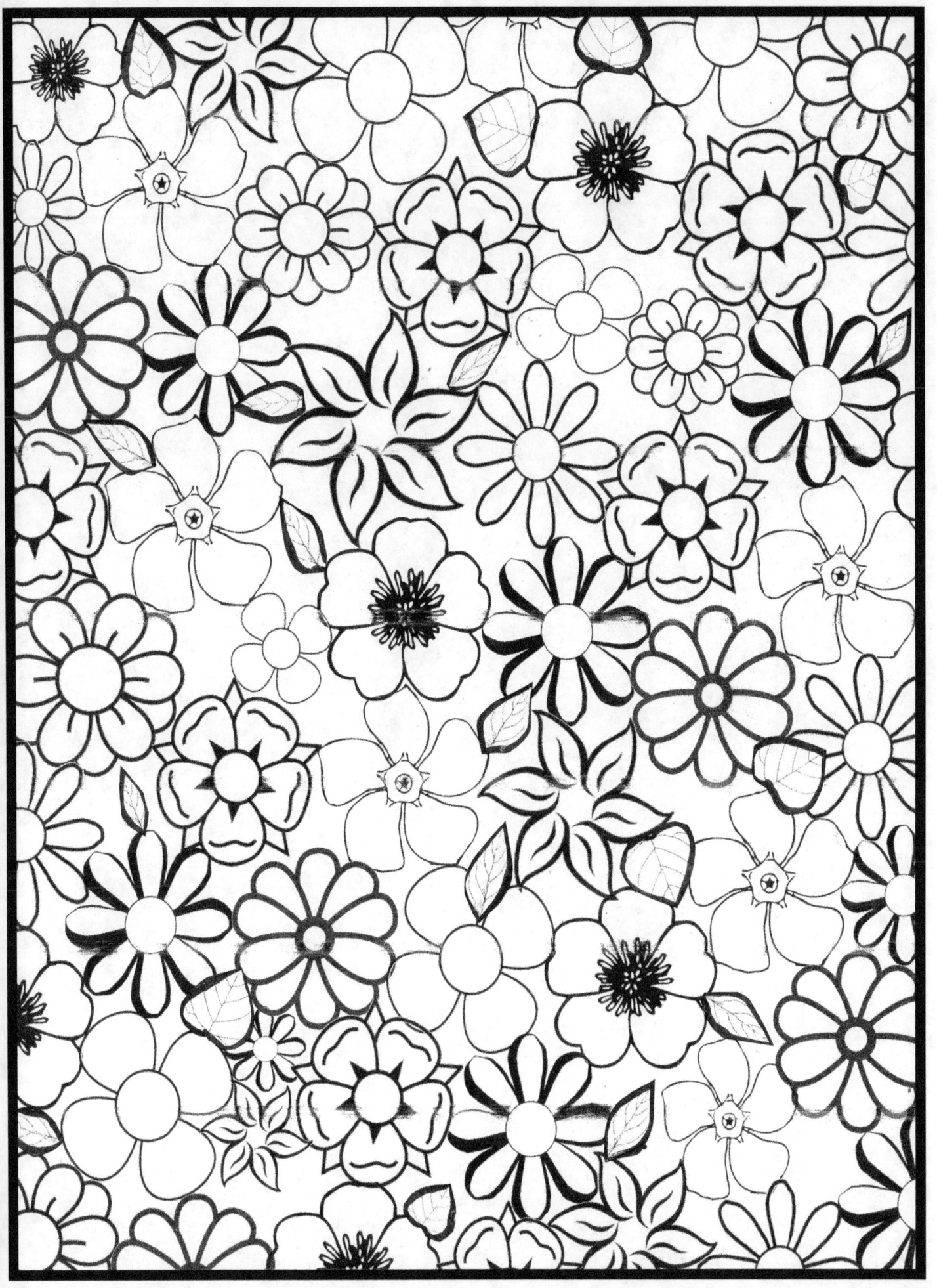

Diddle Daddle Doodles #1
Original Edition

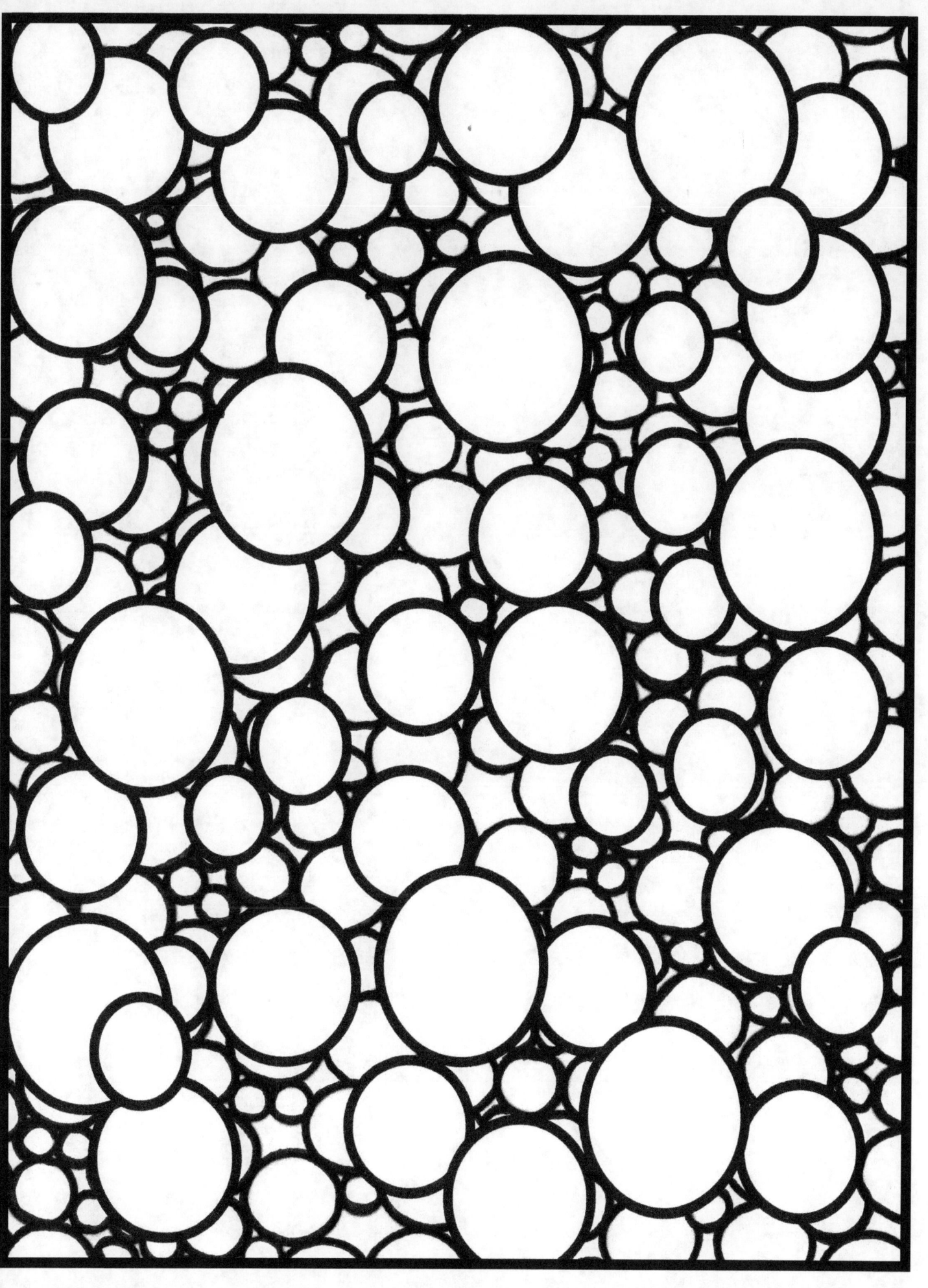

Diddle Daddle Doodles #1
Original Edition

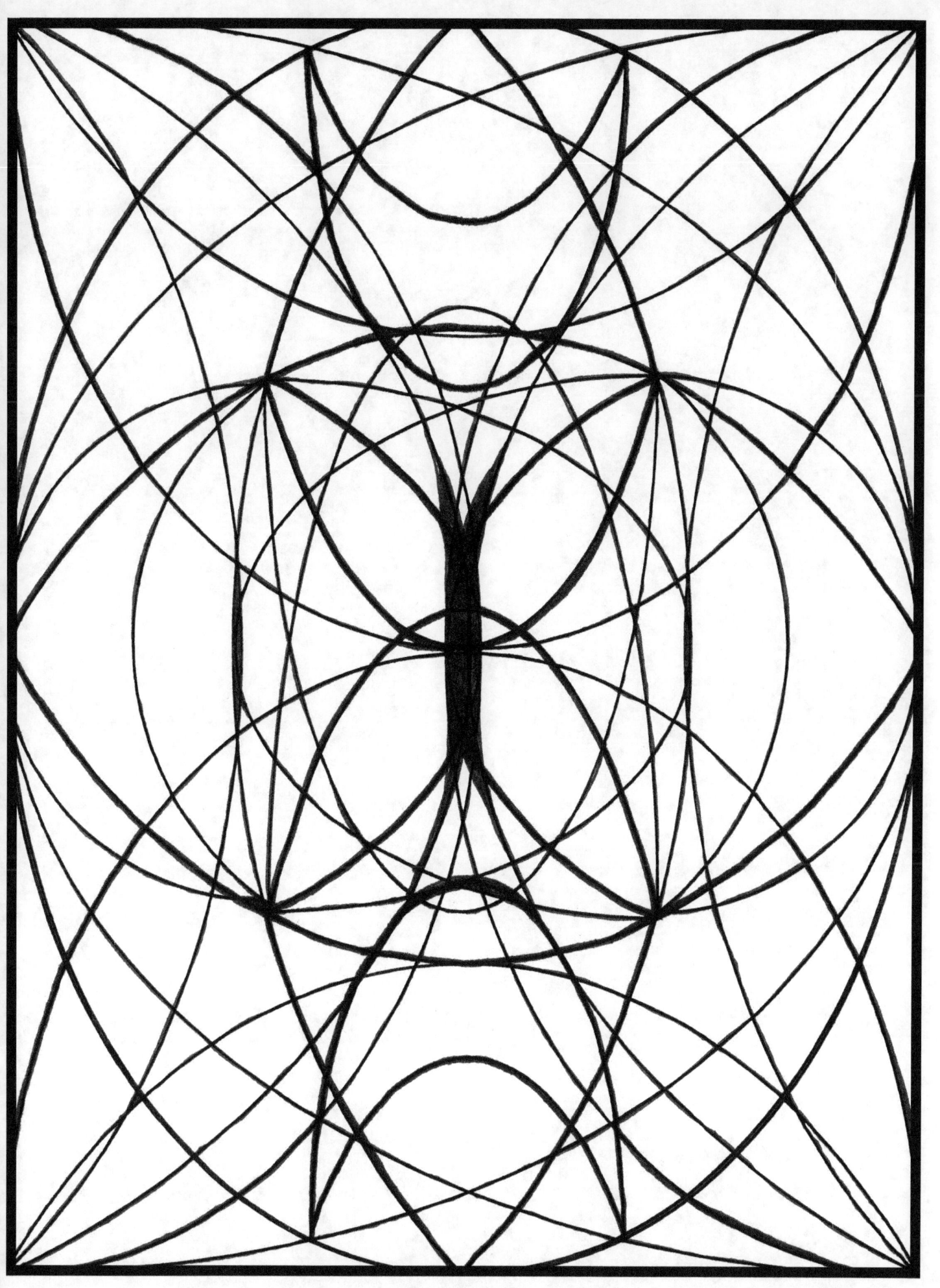

Diddle Daddle Doodles #1
Original Edition

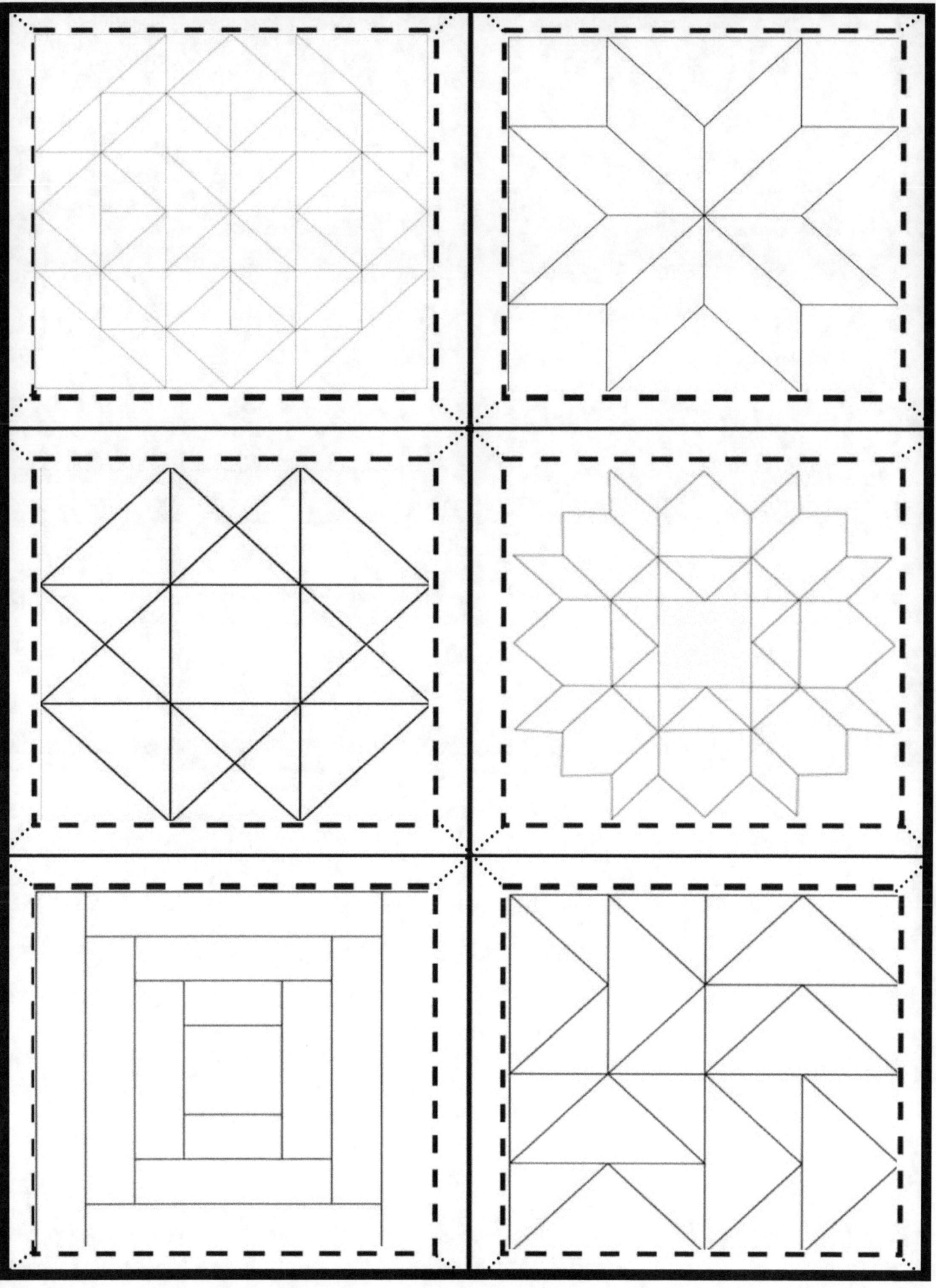

Diddle Daddle Doodles #1
Original Edition

Diddle Daddle Doodles #1
Original Edition

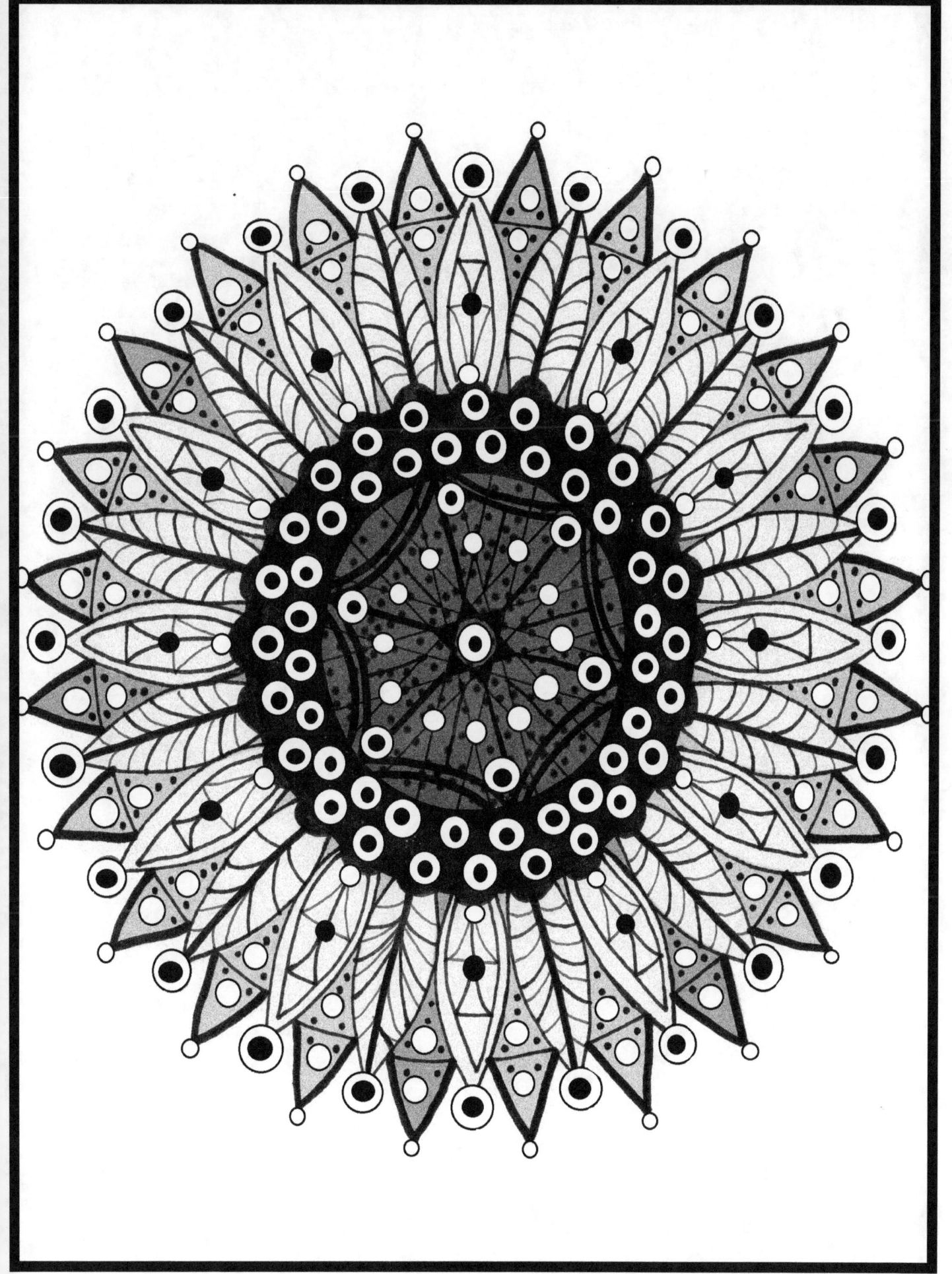

Diddle Daddle Doodles
Original Edition

Diddle Daddle Doodles #1
Original Edition

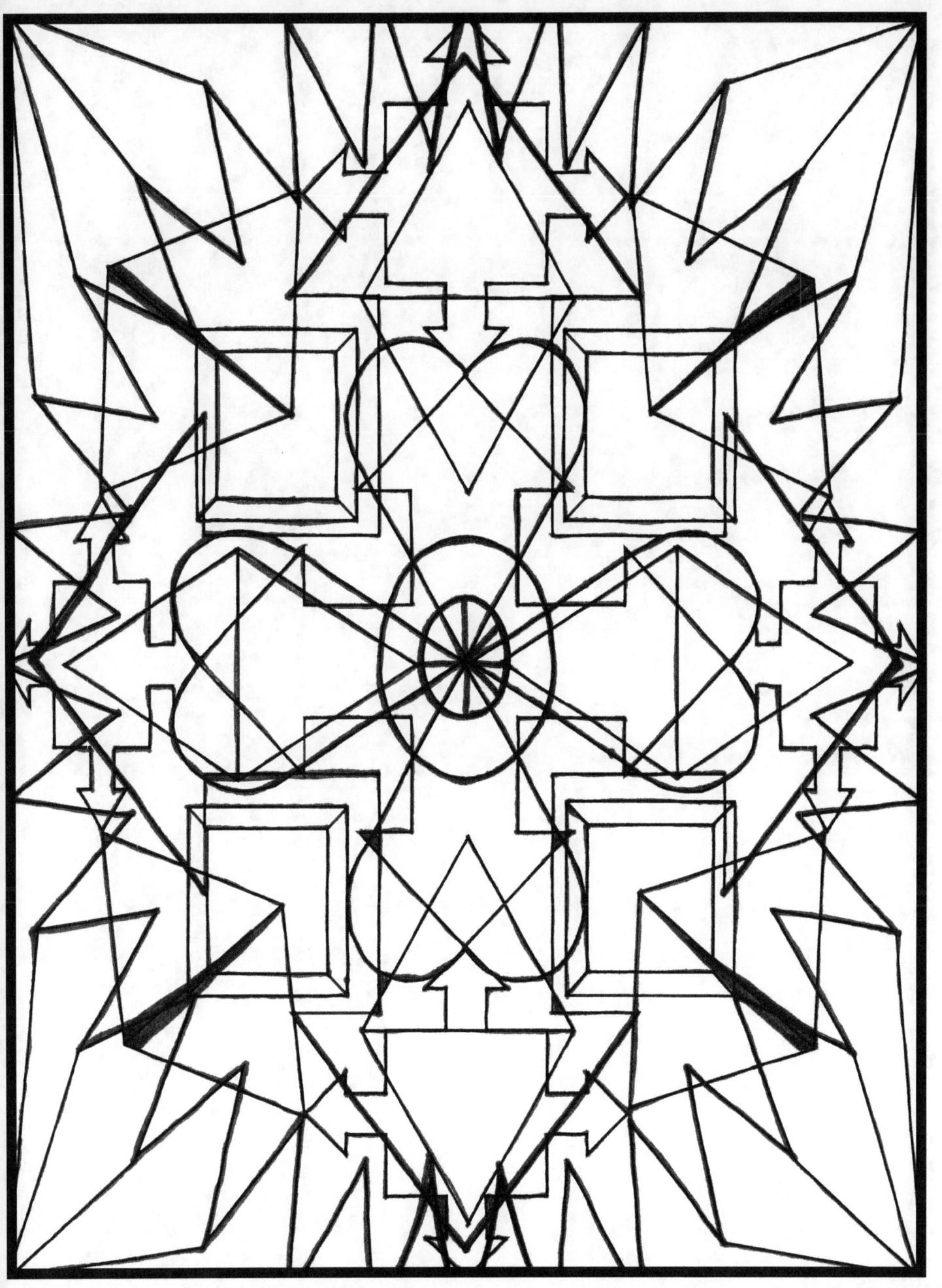

Diddle Daddle Doodles #1
Original Edition

Diddle Daddle Doodles #1
Original Edition

Diddle Daddle Doodles #1
Original Edition

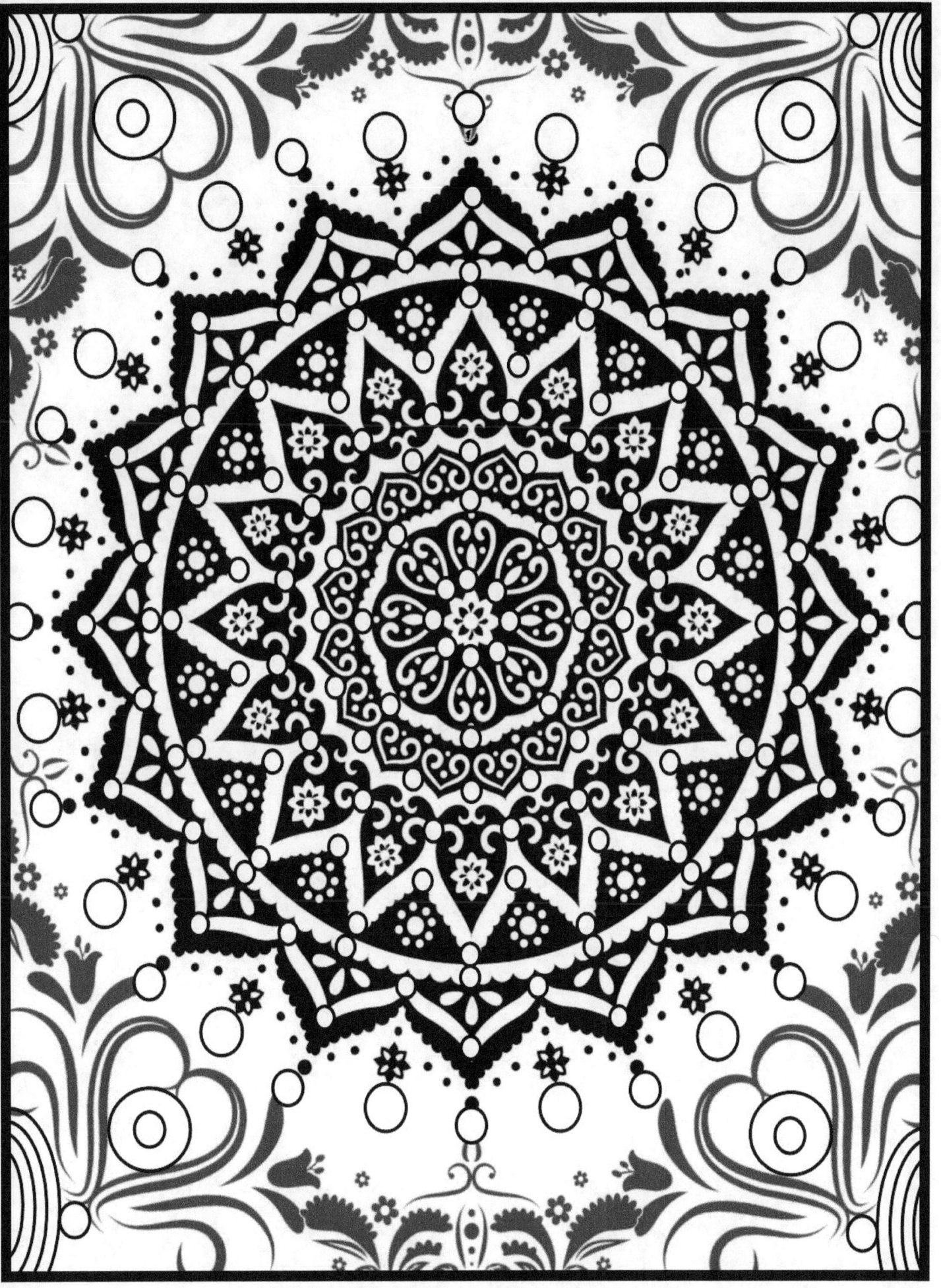

Diddle Daddle Doodles: A Original Edition

Diddle Daddle Doodles #1
Original Edition

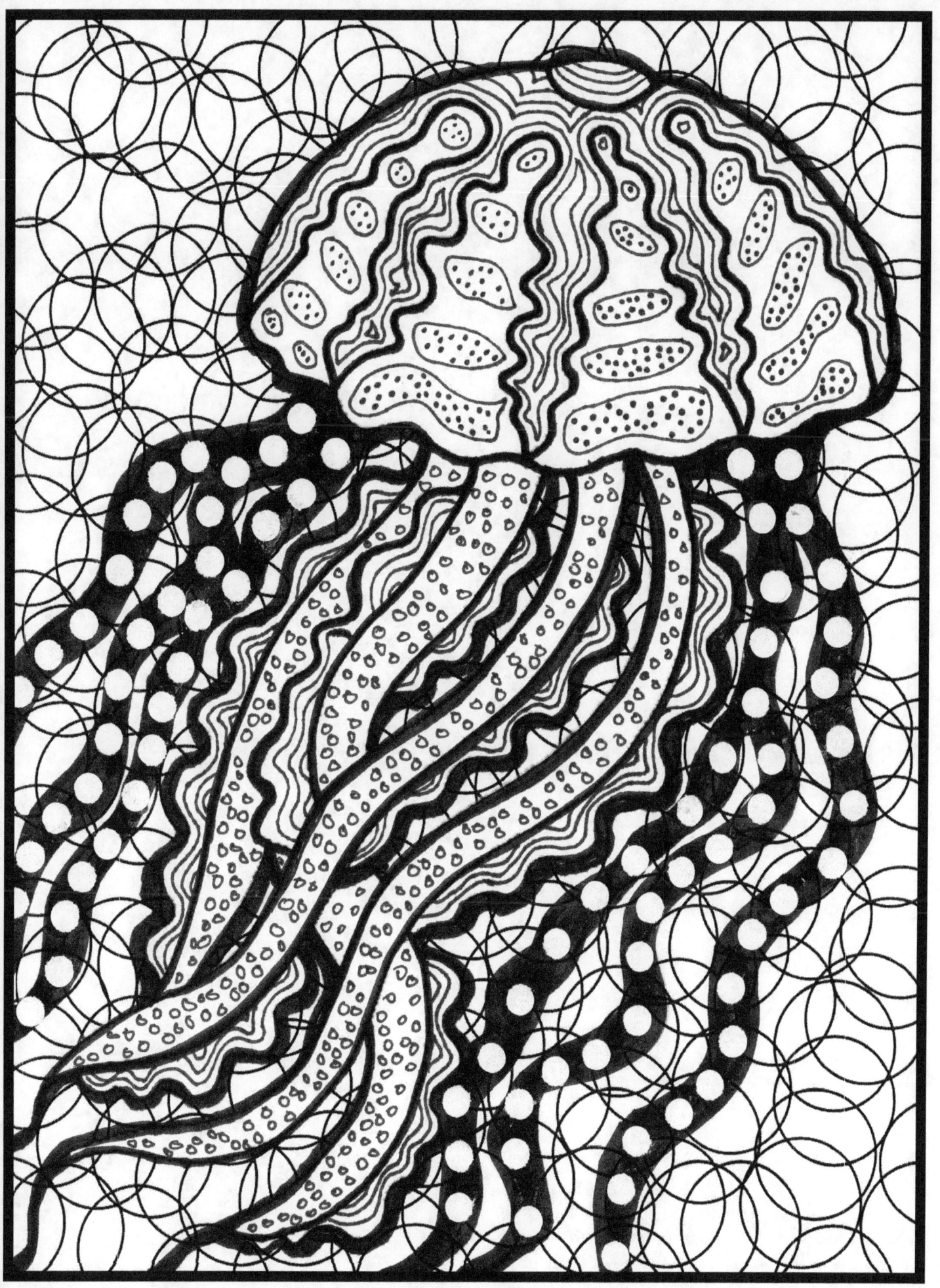

Diddle Daddle Doodles #1
Original Edition

Diddle Daddle Doodles #1
Original Edition

Diddle Doodle Doodles #1
Original Edition

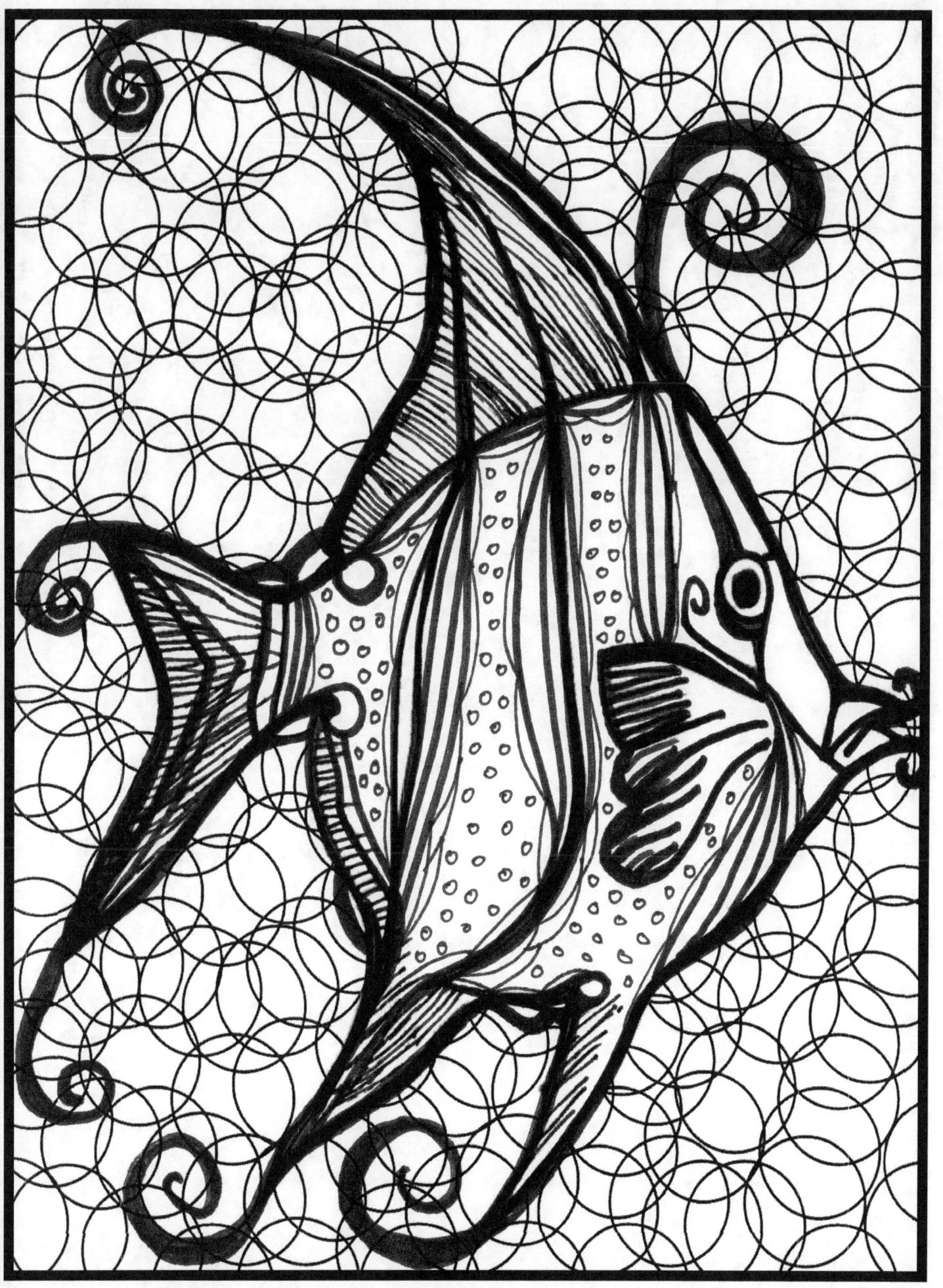

Diddle Daddle Doodles #1
Original Edition

Diddle Daddle Doodles #1
Original Edition

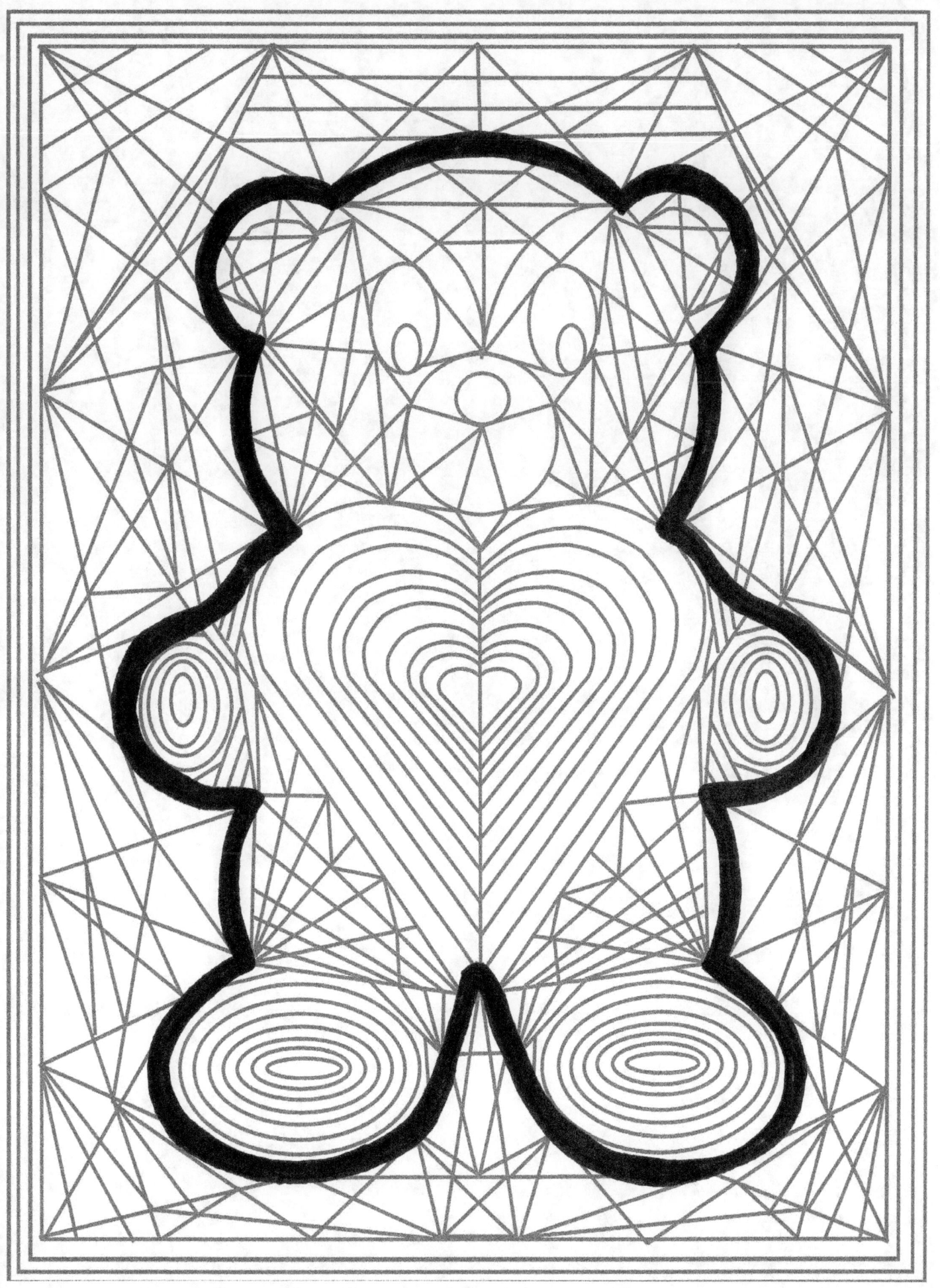

Diddle Daddle Doodles #1
Original Edition

Diddle Daddle Doodles #1
Original Edition

BOOKMARKS

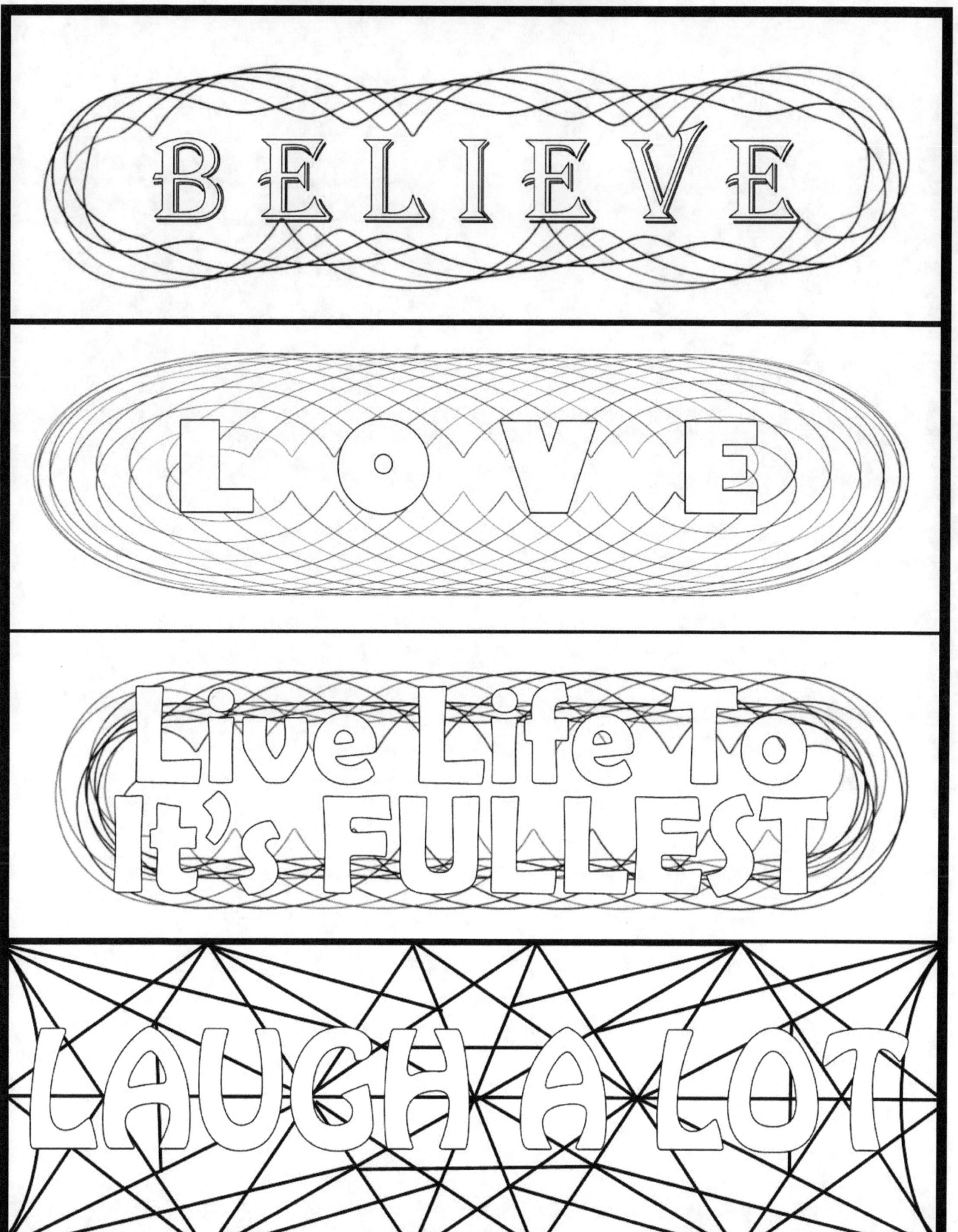

Diddle Daddle Doodles #1
Original Edition

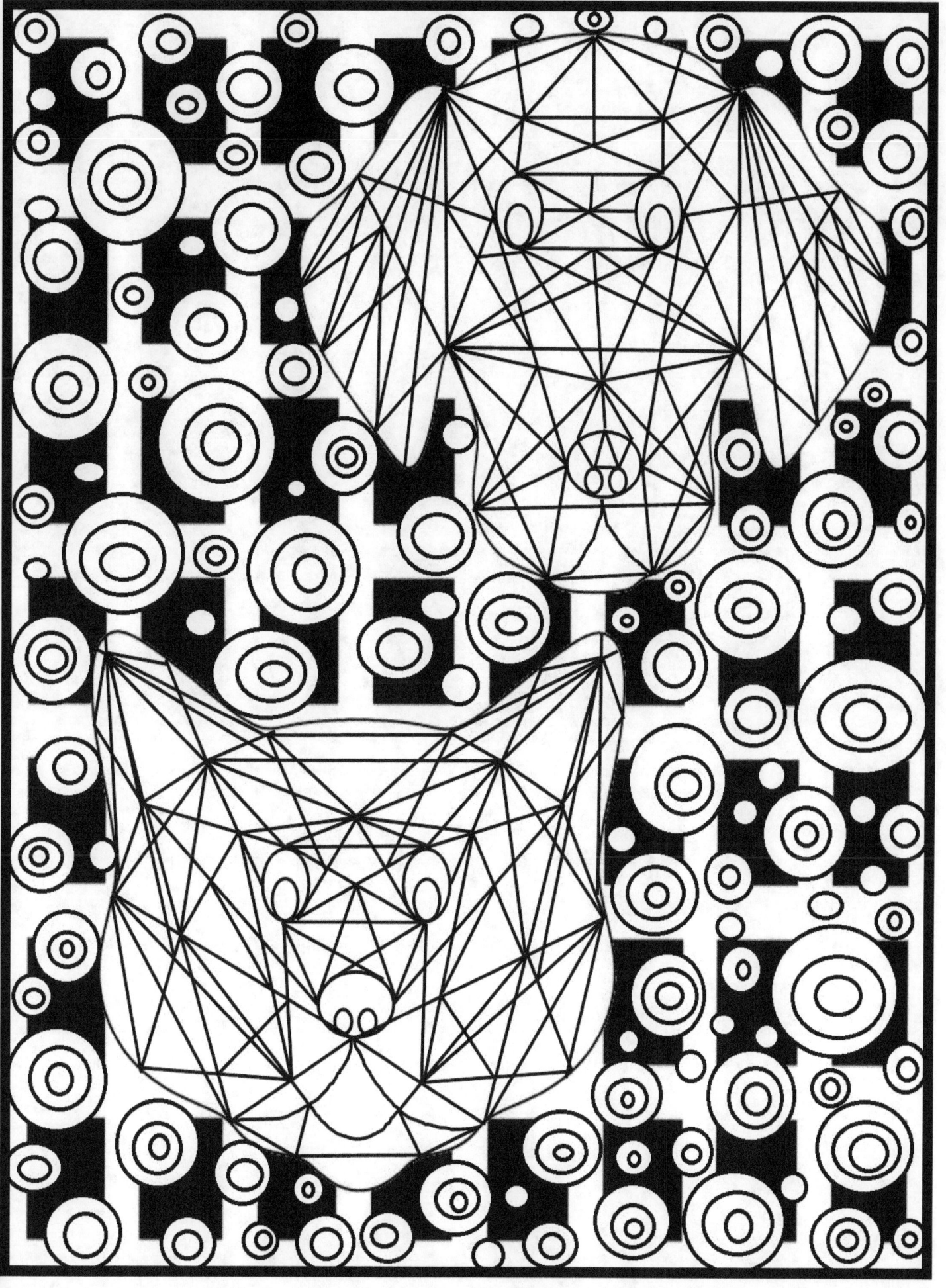

Diddle Doodle Doodies #1
Original Edition